25 Main Street
Newtown, Connecticut 06470

SPOT A CAT

A DORLING KINDERSLEY BOOK

For Annabel

First American Edition, 1995
2 4 6 8 10 9 7 5 3 1

Published in the United States by
Dorling Kindersley Publishing, Inc., 95 Madison Avenue
New York, New York 10016

Library of Congress Cataloging-in-Publication Data

Micklethwait, Lucy
 Spot a cat. — 1st American ed.
 p. cm.
 Summary: Introduces thirteen famous paintings by asking the reader to find the cat in
each one.
 ISBN 0-7894-0144-4
 1. Cats in art—Juvenile literature. 2. Painting—Appreciation—
Juvenile literature. [1. Cats in art. 2. Painting 3. Art appreciation.]
I. Dorling Kindersley, Inc.
ND 1380.S66 1995
750' .1'1—dc20 94–44797
 CIP
 AC

Color reproduction by G.R.B. Graphica, Verona
Printed in Italy by L.E.G.O.

SPOT A CAT

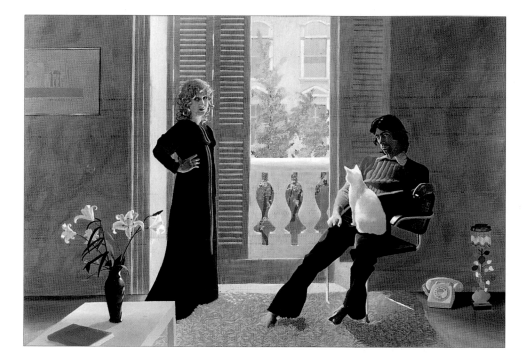

Lucy Micklethwait

DORLING KINDERSLEY
London • New York • Stuttgart

I can see
a big cat.

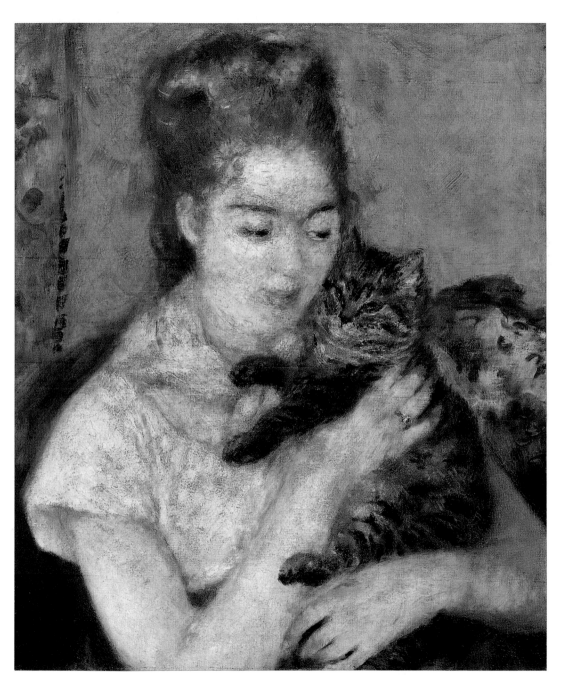

Woman with a Cat Auguste Renoir

Where is the little cat?

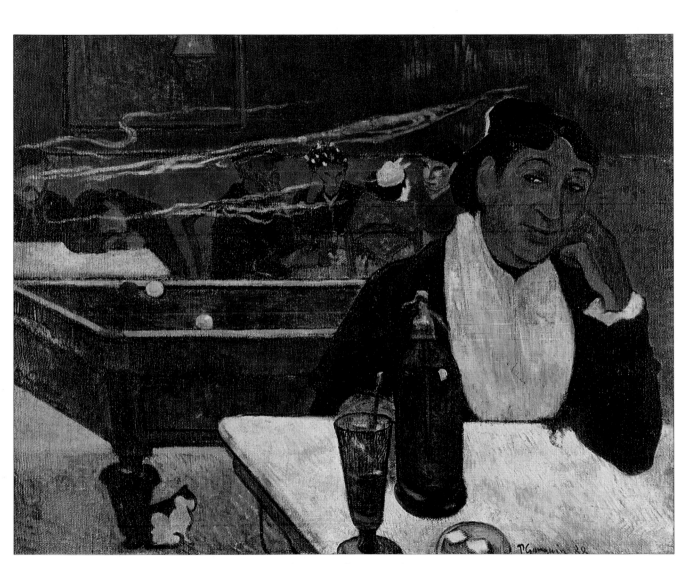

Night Café at Arles Paul Gauguin

Do you see
the scared cat?

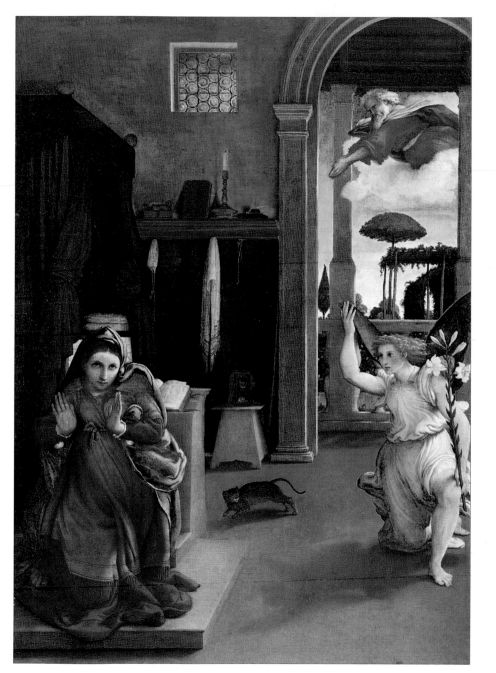

The Annunciation Lorenzo Lotto

Can you spot a cat?

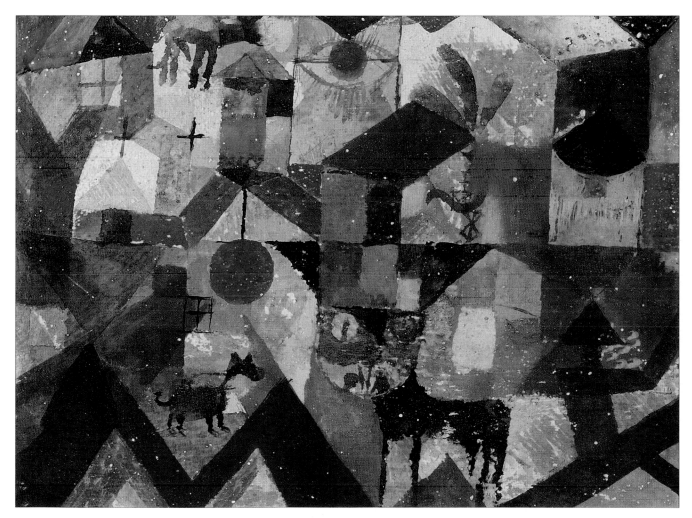

Zoological Garden Paul Klee

This cat is a happy cat.

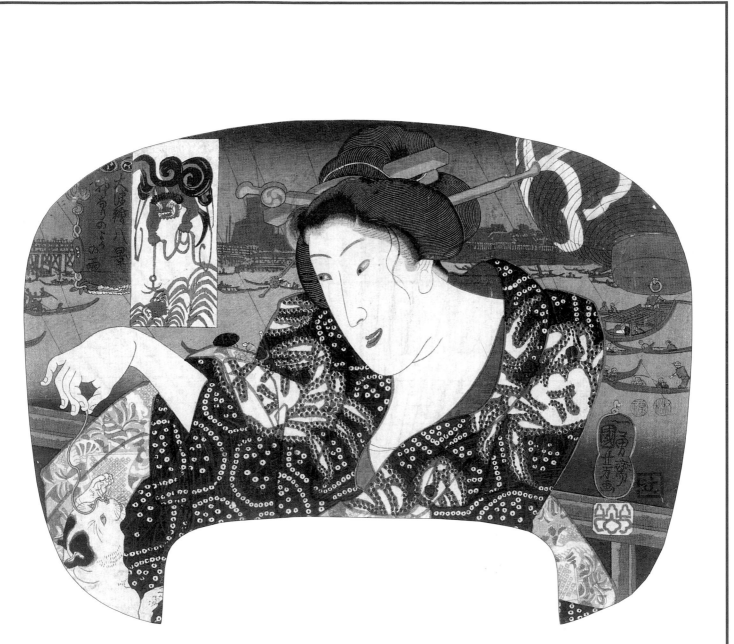

Night Rain and Thunder Utagawa Kuniyoshi

This cat is a cautious cat.

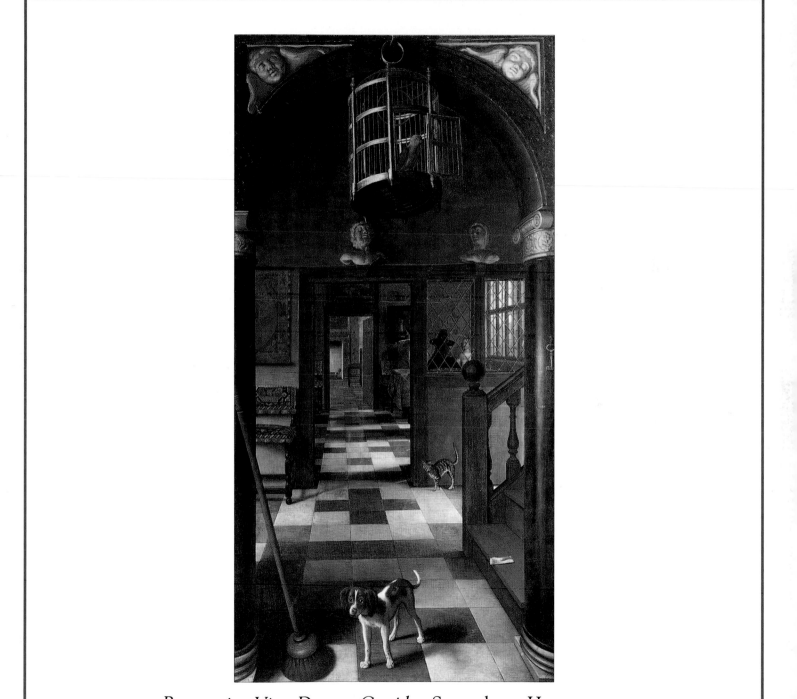

Perspective View Down a Corridor Samuel van Hoogstraten

This one is
a crazy cat.

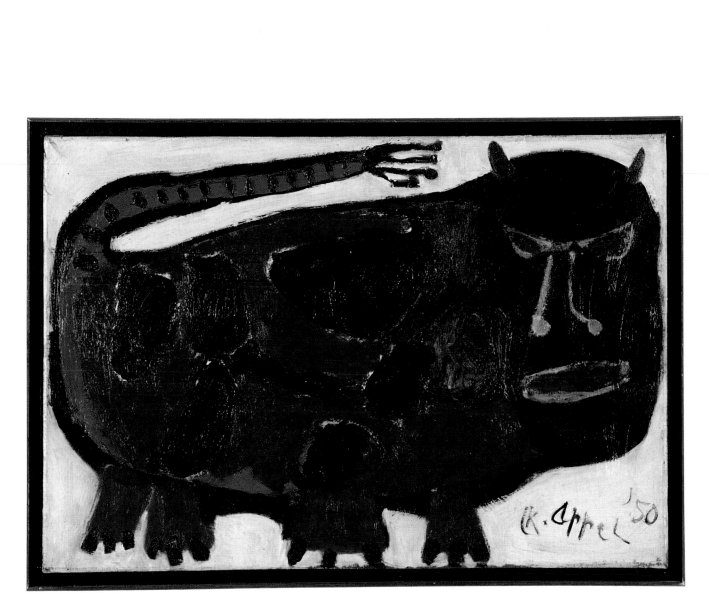

Cat Karel Appel

Can you spot a cat?

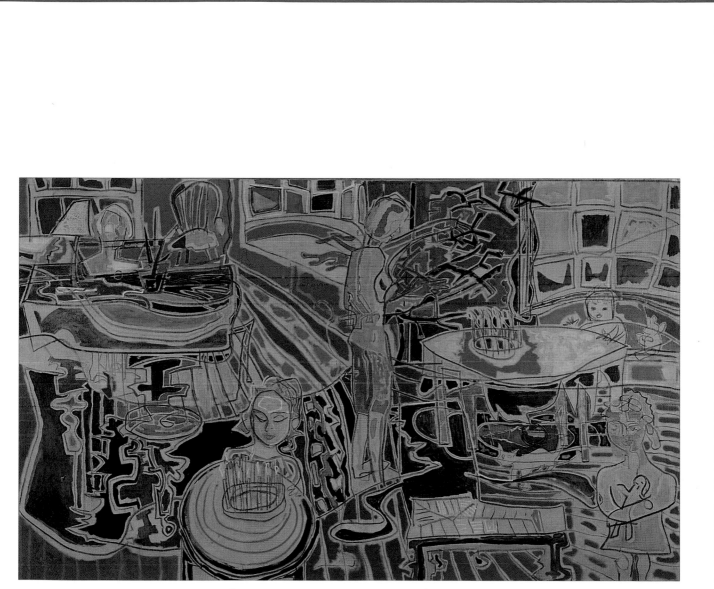

Christmas Eve: 1951 Patrick Heron

I can see a white cat.

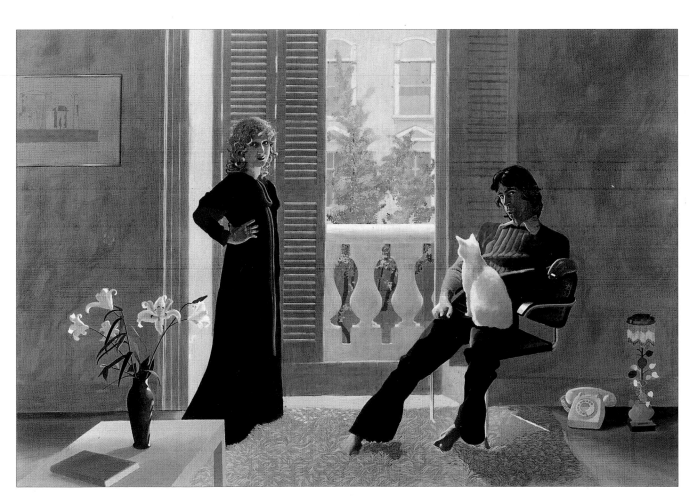

Mr. and Mrs. Clark and Percy David Hockney

Can you see
a black cat?

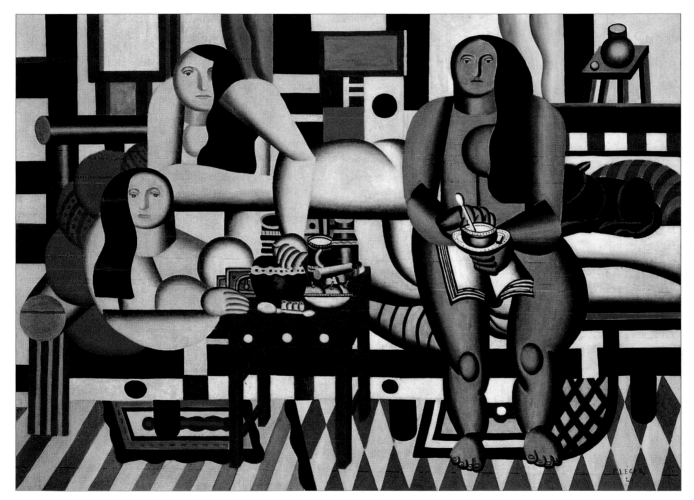

Three Women Fernand Léger

Let's find a ginger cat.

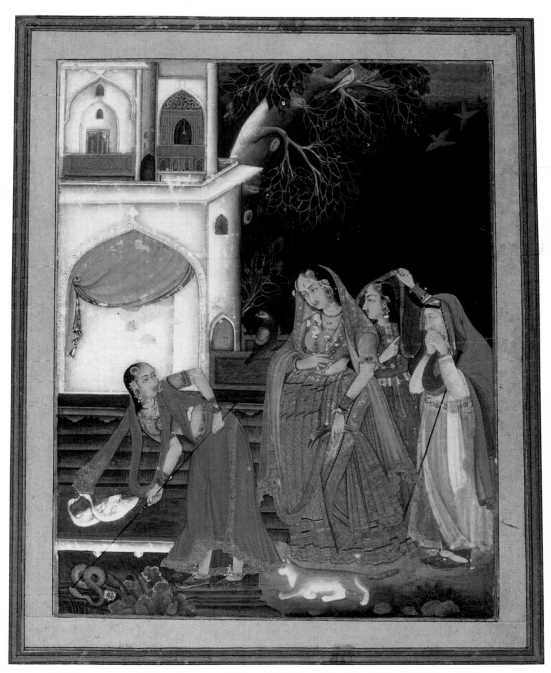

A Princess Watching a Maid Kill a Snake Mir Kalan Khan

Can you spot a cat?

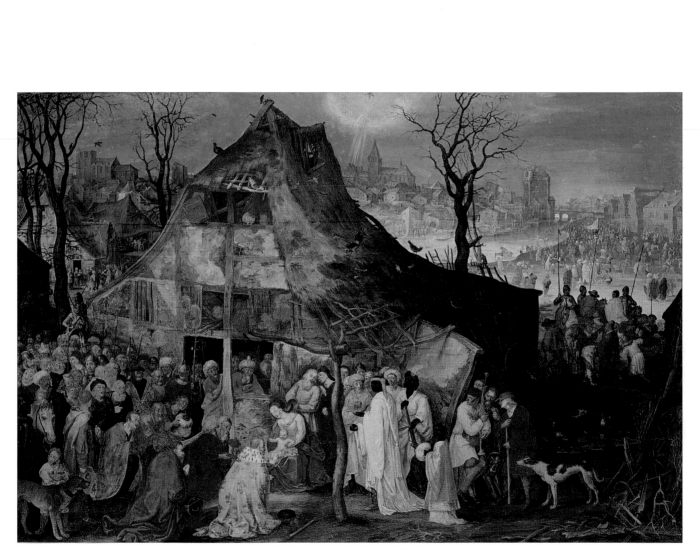

The Adoration of the Magi Jan Brueghel

Here there is a strange cat
And a sort of flappy bat,
But let's find a face
and a foot with five toes.
Do you see the odd dog?
Can you spot the funny frog?
What shall we find . . . who knows?

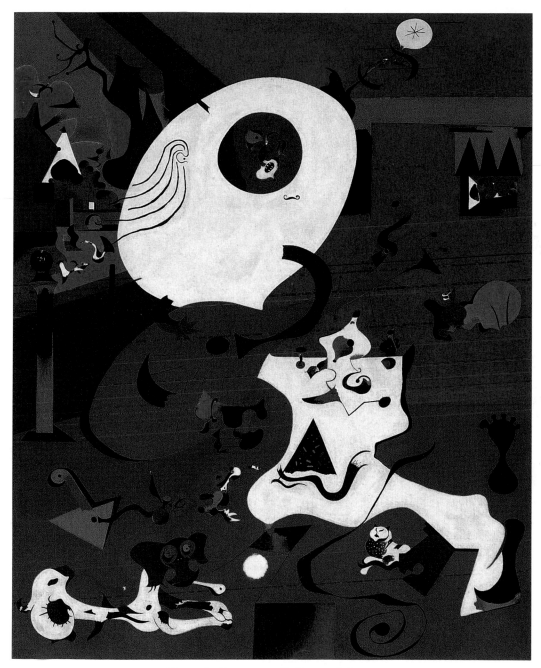

Dutch Interior I Joan Miró

Picture List

I can see a big cat.
Auguste Renoir 1841-1919, French
Woman with a Cat c.1875
oil on canvas
22 x 18¹/₄ in (56 x 46.4 cm)
National Gallery of Art, Washington
Gift of Mr. and Mrs. Benjamin E. Levy

Where is the little cat?
Paul Gauguin 1848-1903, French
Night Café at Arles 1888
oil on canvas
28¹/₂ x 36¹/₄ in (72 x 92 cm)
Pushkin State Museum of Fine
Arts, Moscow

Do you see the scared cat?
Lorenzo Lotto c.1480-1556, Italian
The Annunciation c.1527
oil on canvas
65¹/₂ x 45 in (166 x 114 cm)
Pinacoteca Civica, Recanati

Can you spot a cat?
Paul Klee 1879-1940, Swiss
Zoological Garden 1918
watercolor
6³/₄ x 9¹/₈ in (17.1 x 23.1 cm)
Kunstmuseum, Bern

This cat is a happy cat.
Utagawa Kuniyoshi 1797-1861,
Japanese
Night Rain and Thunder from the series
Beauties and Episodes of Ōtsu-e
early 1850s
woodblock fan print
8¹/₄ x 11¹/₂ in (21 x 29 cm)
(image size)
Victoria and Albert Museum, London

This cat is a cautious cat.
Samuel van Hoogstraten
1627-1678, Dutch
*Perspective View Down
a Corridor* 1662
oil on canvas
102¹/₂ x 53¹/₂ in (260 x 136 cm)
Dyrham Park, Avon

This one is a crazy cat.
Karel Appel b. 1921, Dutch
Cat 1971
oil and papier-mâché on canvas
35 x 45⅝ in (89 x 116 cm)
Private Collection

Can you spot a cat?
Patrick Heron b. 1920, British
Christmas Eve: 1951
oil on canvas
72 x 120 in (182.8 x 304.8 cm)
Private Collection

I can see a white cat.
David Hockney b. 1937, British
Mr. and Mrs. Clark and Percy
1970-71
acrylic on canvas
84 x 120 in (213.4 x 304.8 cm)
Tate Gallery, London

Can you see a black cat?
Fernand Léger 1881-1955, French
Three Women 1921
oil on canvas
72¼ x 99 in (183.5 x 251.5 cm)
Museum of Modern Art, New York
Mrs. Simon Guggenheim Fund

Let's find a ginger cat.
Mir Kalan Khan, Indian
*A Princess Watching a Maid Kill
a Snake* c.1770
gouache on paper
8½ x 6½ in (21.3 x 16.8 cm)
British Library, London

Can you spot a cat?
Jan Brueghel 1568-1625, Flemish
The Adoration of the Magi 1598
body color on vellum
13 x 18⅞ in (32.9 x 47.9 cm)
National Gallery, London

Here there is a strange cat . . .
Joan Miró 1893-1983, Spanish
Dutch Interior I 1928
oil on canvas
36⅛ x 28¾ in (91.8 x 73 cm)
Museum of Modern Art, New York
Mrs. Simon Guggenheim Fund

Front Cover
Woman with a Cat (detail),
Auguste Renoir
Spine
Perspective View Down a Corridor
(detail), Samuel van Hoogstraten
Half Title page
Zoological Garden (detail), Paul Klee

Imprint page
Night Rain and Thunder (detail),
Utagawa Kuniyoshi
Title page
Mr. and Mrs. Clark and Percy,
David Hockney
Picture List
The Annunciation (detail), Lorenzo Lotto
Dutch Interior I (detail), Joan Miró

Note: Measurements are given height by width.

Acknowledgments

The publisher would like to thank the
following for their kind permission to
reproduce the photographs:

Night Café at Arles, Bridgeman Art Library / Pushkin
State Museum of Fine Arts: **7**
A Princess Watching a Maid Kill a Snake, The British
Library / Oriental and India Office Collections: **25**
Cat, Christies Images: **17**
Christmas Eve: 1951, © 1995 Patrick Heron All rights
reserved. DACS: **19**
Zoological Garden, Kunstmuseum, Bern, © DACS 1995:
1 (detail), 11
Three Women (Le Grand Déjeuner), © 1995 The
Museum of Modern Art, New York, © DACS 1995: **23**
Dutch Interior I , © 1995 The Museum of Modern Art,
New York, © ADAGP Paris and DACS London 1995:
29, 31 (detail)

Woman with a Cat, © 1994 Board of Trustees, National
Gallery of Art, Washington: **front cover (detail), 5**
The Adoration of the Magi, The National Gallery,
London: **27**
Perspective View Down a Corridor, The National Trust /
Derrick E. Witty: **spine (detail), 15**
The Annunciation, SCALA / Recanati, Museo Civica:
9, 30 (detail)
Mr. and Mrs. Clark and Percy, Tate Gallery, London
© Tradhart Ltd: **3, 21**
Night Rain and Thunder, Victoria and Albert Museum,
London: **2 (detail), 13**